T0406603

IN THE SUMMER OF 2009

Photographs by Walter Pfeiffer
Design by Matteo Thun

Scheidegger & Spiess

IN THE SUMMER OF 2009

It all started back in the summer of 2009, when I sent our sons Constantin and Leopold—Tin Tin and Poldi—on a road trip to discover the work of their father, Matteo, with my beloved friend (and inimitable photographer) Walter Pfeiffer on their tail. Little did I know then the love story that would unfold.

Travelling from Zurich to Capri, via Mendrisio, Celerina, Milan, Bolzano and Merano, they encountered their father "the architect and designer," discovering the work that had taken him away from them as children and appreciating why as adults—as Walter captured every moment along the way.

It's no secret that I may not have been the best cook in the world when they were growing up, but I know how to get people around a table. To play my part in bringing the men in my life together on this trip was as life-affirming as it was fun (and we had a lot of fun).

In the years that have passed, as everyone has grown up, I've come to realize that what emerged that summer was more than a family album. It was an authentic window on togetherness. A journey, an adventure, a rite of passage, *In the Summer of 2009* is a travelogue that celebrates our roots—one that will forever be a love story for the ages.

Many years later, we looked at the pictures again …
ENJOY !

Manitoba and Volga designed by Matteo for Memphis Milano in 1982 on the terrace of the Thun family home in Milan.

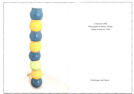

The Chicco Coffee Cup Collection, designed by Matteo for Lavazza in 1998.

Let the adventure start: Poldi and Tin Tin waiting in the Radisson Blu Hotel at Zurich Airport, for which Matteo designed the interiors in 2008.

Poldi layers up for the journey in a little Swiss hotel.

Waiting room: orchids in the Radisson Blu Hotel at Zurich Airport, for which Matteo designed the interiors in 2008.

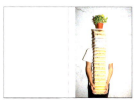

Project pasta: Tin Tin with his fresh pasta takeaway from Vapiano in Zurich, designed by Matteo in 2006.

Ready and waiting: the boys prepare for their trip.

Born four years apart, the boys' connection is strong.

Tin Tin carries the Muse washbasin that Matteo designed for Catalano in 2008 up San Gian Hill in the Engadine Valley.

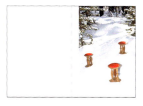

Taking over the forest of Celerina: stools Matteo designed for a private collection in 1988.

A (reluctant) pit stop at home in Celerina as Susanne has Walter shoot her annual family Christmas card.

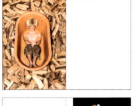

Poldi in the Ofurò wooden bathtub Matteo designed for Rapsel in 2009.

Tin Tin with his cuddly Christmas present from Mama on the family terrace in Celerina.

Breaking protocol in front of the Hugo Boss headquarters in Coldrerio, designed by Matteo in 2006.

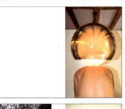

Poldi at Matteo Thun HQ in Milan, basking in the light of the Sconfine Sfera lamp, designed by Matteo for Zumtobel in 2006.

Left: sunflowers in the toilets of Catalano, designed by Matteo in 2008. Right: the Cariatidi glass vases designed by Matteo for Tiffany & Co in 2000.

Heating up: the boys throw shapes in a sauna on the road to South Tyrol.

Exploring the Hugo Boss headquarters in Coldrerio (with clothes on this time), designed by Matteo in 2006.

Left: Inside the Hugo Boss headquarters in Coldrerio. Right: the Flora chair, designed by Matteo for Shaf in 2009, shot by Walter on the Piazza del Duomo in Milan.

Left: Exploring the Vigilius Mountain Resort in South Tyrol, designed by Matteo in 2003.
Right: The Brera Chair in plywood designed by Matteo for Emmemobili in 2009.

Back to nature: in the garden of Terme di Merano in South Tyrol, designed by Matteo in 2005.

The boys get refreshed under the waterfall at Terme di Merano, designed by Matteo in 2005.

Touch wood: pre- and post-dinner reclining on the structure of the Vigilius Mountain Resort, designed by Matteo in 2003.

Poldi and Tin Tin in between takes
(if only Matteo had designed portable changing rooms).

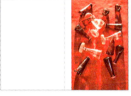

Home in Capri: the Cordial glass collection, designed by Matteo for Campari in 1986.

Left: the boys make friends in South Tyrol.
Right: the Valverde bottles Matteo designed for Spumador in 2008 in the kitchen of Matteo Thun HQ in Milan.

Trying out the prototype rug, Lace, which Matteo designed for Il Piccolo and Nodus in 2009.

Left: Poldi maneuvers the red velvet Casegoods armchair that Matteo designed for Driade in 2007 up the stairs of the studio.

Getting expressive at the Terme di Merano, designed by Matteo in 2005.

A moment of reflection outside the Vigilius Mountain Resort, designed by Matteo in 2003.

Left: the island of Capri.
Right: Poldi takes his skateboard for a spin in the underground parking garage of a private residence in South Tyrol.

The emotive interior of the Terme di Merano, designed by Matteo in 2005.

A bird's-eye view of Poldi and Tin Tin exploring the thermal baths of the Terme di Merano, designed by Matteo in 2005.

Left: Poldi loves being on the road.
Right: Poldi and Tin Tin obeying the sign in the bathroom at the Vigilius Mountain Resort in South Tyrol, designed by Matteo in 2003.

Born posers: the boys throw shapes in the relaxation room of the Terme di Merano, designed by Matteo in 2005.

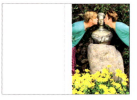

Paying respect to the statue of Sissi in the garden of Trauttmansdorff, Merano.

Ready to take flight in Maison Margiela feathers at the viewing platform in Trauttmansdorff, Merano, South Tyrol, designed by Matteo in 2005.

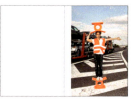

Any excuse for a shot: a traffic jam gives the trio time to shoot Tin Tin standing on the Tam Tam stool Matteo designed for Magis in 2002.

Left: a pit stop in Capri with Matteo showing Tin Tin how to sit on the Tam Tam stool in his favourite Comme des Garçons trousers.
Right: Poldi behind a Missoni curtain as he explores the Matteo Thun studio in Milan.

Plumbago in full bloom in the family garden on Capri.

Left: the Twin 1731 knife designed by Matteo for Zwilling in 2008, shot on a Dries Van Noten top and a mosaic table on Capri.
Right: the boys get to grips with the Lido beach ball prototypes Matteo designed for Alcantara in 2009.

Poldi and Tin Tin take a break on Capri.

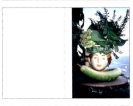

A vase from Caltagirone in Sicily with a courgette from the family garden on Capri.

Left: the famous Faraglioni rocks in Capri.
Right: Walter and Susanne under the lemon trees (photographed by Tin Tin).

Devil in the detail: Walter finds Susanne's special table…

Left: Tin Tin preps for the day.
Right: the Thun family breakfast table on Capri.

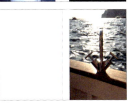

A day at sea: the ISY Arc tap, designed by Matteo and Antonio Rodriguez for Zucchetti in 2009.

Poldi and Tin Tin let off some steam aboard a little fishing boat in the waters off Capri.

…and the childish playfight carries on.

Left: exploring grottos on Capri.
Right: Poldi making his mother's heart stop.

Left: Poldi playing it cool…
Right: …and later cooling off.

The island of Capri, home to the Thun family and many friends
who have stayed over the years.

The Via Col Vento glass Matteo designed for Campari in 1986.

The third child: the Thun family dog Jackie, named after
Mrs. Onassis; a Jack Russell who had a mind of her own and
a heart of gold.

Buon appetito: lunch is served on a Dune plate designed
by Matteo for Villeroy & Boch in 2002.

Left: the wristwatch collection Matteo designed for friends in 2003.
Right: the blue glass vase prototype Matteo designed for Tiffany & Co
in 1990.

The boys air their laundry as they prepare to hit the road again.

Packing can be tiring work.

Left: the boys model the (S)unlimited sunglasses Matteo designed
for Silhouette in 2008.
Right: Susanne turns the camera on Walter.

Left: an impromptu fashion shoot in the lemon grove featuring
vintage Versace.
Right: Tin Tin showing off his diving skills.

The crystal vase collection Matteo designed for Theresiental in 1995.

Left: the Thun family's beloved Grotta Bianca.
Right: Walter planning his next steps.

Left: a limited-edition watch on a tile at home in Capri, designed by Matteo for Swatch where he was art director from 1990 to 1993.
Right: the trio reach the Church of San Gian in Celerina in Switzerland.

Poldi and Tin Tin defy gravity on a staircase at the Vigilius Mountain Resort in South Tyrol, designed by Matteo in 2003.

Left: the Matteo Thun Studio in Milan with the marble centrepiece Matteo designed for Upgroup in 1998.
Right: the Walter appreciation club.

Susanne and Matteo in the Grotta Bianca on Capri.

The Chicco coffee cup designed by Matteo for Lavazza in 1998.

Thun family dogs Toni and Ara relaxing on vintage chairs at the family home on Capri.

SPECIAL THANKS GO TO

Walter Pfeiffer. Matteo Thun. Constantin Thun. Leopold Thun.
Marie Lusa. Thomas Kramer. Scarlett Conlon.

Alcantara
Bisazza
Campari
Catalano
Driade
Emmemobili
Hugo Boss
Il Piccolo
Lavazza
Lobmeyr
Magis
Memphis Milano
Missoni
Nodus
Radisson Hotels
Rapsel
Silhouette
Swatch
Terme di Merano
Trauttmannsdorff Meran
Tiffany & Co
Upgroup
Valverde
Vapiano
Vigilius Mountain Resort
Villeroy & Boch
Wittmann
Zucchetti
Zumtobel
Zwilling

IN THE SUMMER OF 2009 is edited by Susanne Thun
Conception: Susanne Thun, Marie Lusa & Walter Pfeiffer
Photographs: Walter Pfeiffer
Coordination & Book design: Marie Lusa, Studio Marie Lusa
Images retouching: Sabina Bösch
Managing editors: Susanne Thun, Scarlett Conlon
© 2023 Matteo Thun, Walter Pfeiffer, and Verlag Scheidegger & Spiess AG, Zurich

ISBN 978-3-03942-137-4

Verlag Scheidegger & Spiess, Niederdorfstrasse 54, 8001 Zurich, Switzerland
Scheidegger & Spiess is being supported by the Federal Office of Culture with a general subsidy for the years 2021–2024.